T0146500

ART HISTORY
AND
CONNOISSEURSHIP

ART HISTORY
AND
CONNOISSEURSHIP

Their Scope and Method

BY

W. G. CONSTABLE

Curator of Paintings, Museum of
Fine Arts, Boston, Mass.

Formerly Slade Professor in the
University of Cambridge

CAMBRIDGE
AT THE UNIVERSITY PRESS
1938

CAMBRIDGE UNIVERSITY PRESS
Cambridge, New York, Melbourne, Madrid, Cape Town,
Singapore, São Paulo, Delhi, Mexico City

Cambridge University Press
The Edinburgh Building, Cambridge CB2 8RU, UK

Published in the United States of America by Cambridge University Press, New York

www.cambridge.org
Information on this title: www.cambridge.org/9781107619333

First published 1938
First paperback edition 2013

A catalogue record for this publication is available from the British Library

ISBN 978-1-107-61933-3 Paperback

PREFACE

The substance of the earlier part of the following apologia was given in a lecture at the Royal Institution; of the latter part, in an inaugural lecture as Slade Professor at Cambridge.

W. G. C.

1938

The History of Art, that shrine of grave
and mellow light around the mute Olym-
pian family.

PATER, *Essay on Winckelmann*

§ i

ART HISTORY may be defined as the history of man as a maker of material things into which an aesthetic element enters. Like most definitions, this is not a self-evident proposition but a statement needing explanation and development. In the first place, art history is one side of human history, since the works of art which are the main material of its study, incorporate and objectify a movement of the human spirit, the impulse to create. Secondly, more as the result of custom and convenience than on logical grounds, the art historian limits his field to things which are tangible and material, excluding the arts of literature, the drama, and music from his scope. Thirdly, he imposes on himself the further limitation, that the work he studies should embody an aesthetic element, the desire or instinct to create for the sake of creation, to establish certain relations or rhythms, which the maker of the thing found interesting and exciting.

It is important to realise that the art historian does not postulate a kind of aesthetic man, comparable to the economic man of the earlier economists, whose sole motives for action are creation

for its own sake. In the making of anything, men's motives are likely to be very mixed, ranging from forces such as economic necessity and political pressure at one end of the scale, to unalloyed and disinterested joy in creation at the other. But whenever the desire or instinct is present to establish relations or rhythms in a material, apart from the wish to make the work serve some purpose other than aesthetic, then the article is in some measure a work of art, and is material for the art historian.*

Subject to this limitation, the art historian is concerned with the whole range of material things made by man at any period in his history. His concern is not only with painting and sculpture, but extends to architecture and the whole range of the crafts, including the products of machines as well as of men's hands. For him the distinction which developed and hardened during the nineteenth century between the fine arts and the crafts does not exist. That distinction is usually made to rest on whether an object is primarily designed as a work of art, and to serve no purpose except to exist as such, or whether it is primarily designed to serve a useful purpose. In fact such a distinction cannot be effectively applied, since no measure of degrees of aesthetic intention is possible; while in practice

* This of course does not mean that the form in which the aesthetic element expresses itself is independent of the purpose the work is to serve. It is likely, on the contrary, to be governed by it.

it eliminates most architecture and much painting and sculpture from the class of the fine arts. Moreover it obscures or obliterates the fundamental distinction between a work of art and a merely useful object, which consists in the presence or absence of some degree of aesthetic intention.

Such being the scope of the art historian's work, the next step is to consider the relation of his field of study to that of others. As will appear later, the art historian's special task brings him into contact with almost every branch of learning. In many of these, such as theology, law, philology, and the sciences, there is no confusion as to area of work; and contact mainly takes the form of the one study taking from the other ascertained results as material for its own purposes. But in some cases the relation is less clear.

Take first those studies whose material differs though they pursue similar methods. The study of each type of history calls for a special equipment and training; and it is justifiable therefore and indeed indispensable that the various types should be studied separately. But this should not blind the historian of one kind of activity to the existence of the others, which may limit and condition the activity with which he is primarily concerned. So the art historian must be prepared to study man as a producer of works of art in relation, for example, to the political, economic, literary and religious

⟨ 3 ⟩

activities of the period; and in relation to such changes as those in geographical, climatic and geological conditions. *Mutatis mutandis*, this applies to any other type of historian. The importance of this way of regarding historical studies is that it explodes what may be called 'the spirit of the age' fallacy. Too often the art of an age has been regarded as something which merely expresses that 'spirit', whose character is regarded as determined by other types of activity independently of the art. In fact if the term 'the spirit of the age' has any meaning at all, the artistic activity of the age is just as much a contributor to that spirit as any other form; and any estimate of such a spirit must take into account art equally with other factors.*

Turn now to the group of studies concerned wholly or in part with the same material as art history, but differing in object or method or in both. Chief among these is archaeology. It used to be customary to base the distinction between archaeology and art history on period, and to limit the work of the archaeologist to comparatively re mote times and mainly to the discovery of material.

* It is permissible to argue that certain kinds of activity, political and otherwise, are more important than others, and their history therefore better worth studying. That however raises a set of considerations not relevant here. It may however be remarked that in any reasonable Utopia, most of the buildings in Whitehall would become distasteful superfluities; but the National Gallery at one end and Westminster Abbey at the other would be possessions even more cherished than today.

Clearly such a distinction has no logical basis. It perpetuates one derived from days when art history had received little serious attention, while archaeology, primarily under enthusiasm for classic art, devoted itself mainly to excavations. It corresponds in some degree to the distinction between archivist and historian; and though it is often convenient and sometimes essential to divide an area of study between those who search for material and those who work upon it, there is nothing to prevent the two kinds of work being carried out by the same person, and in fact this frequently happens.

It is after the material is available for study that the true distinction between art historian and archaeologist emerges. Up to a point, even then, their work coincides. It is essential for both to discover exactly what the object before them is and to establish its date and provenance; and in so doing, they adopt similar methods. But for the art historian the object is only of significance in so far as it to some extent embodies an aesthetic intention, and is therefore in some measure a work of art. If in his judgment it does not do so, then it falls outside his scope; and the extent to which he considers it a work of art will determine the degree of its significance within the range of his observation. In contrast, every object is of interest to the archaeologist so far as it throws light on human activity of any kind; and it is his business not to pick and choose but to make clear the character, date and

provenance of objects, so that the historian of any type can use them and estimate their significance in his own particular field. There is of course nothing to prevent the archaeologist himself using material as the basis for historical study of various kinds, including art history; but in so far as he does so, he passes beyond the bounds of archaeology into those of history.

The increasingly high standard in archaeology and the development in its technique are producing a notable tendency for archaeologists to confine themselves to the collection, definition and arrangement of material, leaving the business of interpretation to others; with the great advantage that new material is not collected to uphold any particular thesis, and so the risk of bias and neglect is avoided. This tendency is mainly observable however in fields where the need for technical knowledge is greatest, such as the excavation of early sites; and outside these in many cases the art historian has still to be his own archaeologist.

The foregoing discussion raises the important question as to how the art historian is to tell whether an object is relevant to his own particular field; in other words, whether it is a work of art. Here he has to leave the world of objective tests. The creative impulse in which a work of art originates is non-rational and comes from the unconscious; and in the process of objectifying it, intellect and emotion are inextricably mixed. What is born

of the emotions can only be fully apprehended by the emotions. 'The wind bloweth where it listeth, and thou hearest the sound thereof, but canst not tell whence it cometh, and whither it goeth: so is every one that is born of the Spirit.' It is through the emotions that the art historian has to judge whether he is in the presence of a work of art. It is perhaps possible to rationalise the experience of a spectator of a work of art and to say that such-and-such characteristics of the object caused the experience; but it has yet to be shown that the possession of those characteristics necessarily makes an object a work of art, and so we are thrown back on the emotional test. It is the peculiar difficulty and the peculiar glory of the art historian's task that this should be the case. He has to bring to his work not only the same intellectual curiosity, the same powers of discernment, the same powers of weighing evidence as the political or economic historian; but he has also to cultivate and train his emotional power to comprehend what the artist has sought to express in terms of material.

But this necessity does not complicate the art historian's task as much as might be expected. Very few things indeed are made by man into which some aesthetic element does not enter, and its total absence is as a rule easily perceptible. Considerably more difficult is it to appraise the extent of this aesthetic element, and so to judge the significance of an object as a work of art. But just as the political

or economic historian has to estimate the importance of an event in his own field, so the art historian has ultimately to estimate the importance of a work of art in the history of art, since in that history the main events are works of art themselves. Further discussion of this point comes later; its relevance here is that it raises the question of the relation of the art historian to the philosopher, and to the art critic.

The material which for the art historian constitutes his whole field, is for the philosopher only one corner of a vast domain. That part of philosophy known as aesthetics has inspired a vast amount of writing, mainly on a metaphysical basis and from an *a priori* standpoint, none of which has yielded results of much interest to the art historian. Today however, with the aid of the psychologist, the philosopher interested in aesthetics is directing his attention more specifically to three problems: What constitutes a work of art? How does it come into being? and, How is it experienced?

Of these three questions, the first, What constitutes a work of art? is the most important for the art historian, since his selection of material may be determined by the answer. But even if the philosopher and the psychologist supply an answer, it is doubtful whether it will put the art historian in a better position than he is now, since the test is likely to remain primarily subjective. The second question, How does a work of art come into being?

is also of some importance. A satisfactory answer should enable the art historian to see more clearly how each stage in the creative process is affected by various influences, and thereby to estimate more exactly the reasons why a particular work of art has taken such-and-such a form. The third question, How is a work of art experienced? only becomes interesting to the art historian in so far as he sets out to estimate the significance as works of art of the objects with which he deals. Even the most complete answer will not settle the value of an object as a work of art. But it may contribute to this by helping to ascertain both the character and the quality of individual reactions to works of art, which will yield material for comparison of different works of art.

It is in this process of evaluation that art historian and art critic tread on common ground. Their relation is not unlike that of a political historian and a politician; the historian is primarily occupied with the problem of what happened and why it happened, the politician primarily with judging whether a given course of action is advantageous or not. Like the political historian, the art historian, in his business of explaining why a work of art has taken a particular form, may have to judge not only the importance of a work of art as an historical event, but to estimate whether such-and-such forces worked for good, others for evil, and to imply that a particular work or group of works

constitute a peak in man's artistic activity, others a depression. But the application of such a measuring rod of merit, as distinct from historic importance, is not an essential and indispensable part of his work; and provided he does not cook his facts to justify his preferences, his work may still remain of use, however misguided his estimate of merit might be. The art critic is in a different position. With him all study is directed towards making a judgment as to whether a work of art is good or bad; and by that judgment he stands or falls.

These judgments of aesthetic value play a large part in what is called 'art appreciation'. Thought of mainly as a teaching subject, this appears today to be mainly directed towards awakening or stimulating an interest in the arts and in providing standards of judgment as to whether a work should be admired or not. It falls therefore within the sphere of art criticism rather than art history. The art historian may provide valuable material for art appreciation, just as he may for serious art criticism; since his concern with what is present in works of art and why it is there involves systematic analysis of works of art and understanding of the circumstances in which they came into being. In other words, he lays the foundation for understanding the language of the artist. But art appreciation is not his primary purpose.

In considering the relation of art history to other

studies, a clear distinction must be maintained between the study of a work of art as a work of art, and its study as a document for use in other fields. For example, the political, economic and social historian may find valuable material relating to life at different periods in works of art; and important information relating to personalities through the study of portraits. The art historian may produce such material as *parerga* to his own proper study, and should regard it as his duty to do so on occasion. But he should always remember that his prime business is the history of man as a producer of works of art, not as an illustrator of the men and manners of a period.

§ ii

THE art historian's work has thus four main aspects:

(i) Collection of material.

(ii) Study and analysis of its character and consequent grouping and classification.

(iii) Investigation of why the material has taken a particular form at a particular time and place.

(iv) Estimation in relation to other material of its importance, historical certainly, and possibly aesthetic.

The methods of pursuing these various kinds of activity now need consideration.

It is necessary to emphasise that the main material with which the art historian has to deal are works of art. Documents, oral or written tradition, and the writings of other scholars play their part as in other types of history, and are used in the same way; but the art historian has the great advantage over other historians of dealing mainly with first-hand material. 'All that remains of an event in general history is the account of it in document or tradition; but in art, the work of art itself is the event.'* This advantage over other historians,

* Berenson, *Study and Criticism of Italian Art*, 2nd series, p. 120.

however, is to some extent neutralised by the difficulty for the art historian of collecting his material round him, and the consequent necessity of going himself to examine it. Thus, constant visits to galleries, museums and private collections; frequent travel in his own country and abroad; and residence for a considerable period in important art centres, are indispensable to an extent and in proportions determined by the particular piece of work the art historian has in hand. Another complication is the immovability of many works of art, which makes comparison of one with another difficult.*

But compared with his predecessor of a hundred or even fifty years ago, the art historian of today is well off. Improvements in transport, and in particular the development of the motor-car, have not only made many works of art more accessible but have reduced the time needed for travel. The growing numbers of museums and galleries, the enlargement of their collections and improvements in their organisation, have increased greatly the amount of material easily to be seen; and developments in the use of photography and reproduction processes have enormously increased the ease of comparative study.

But the increasing use of photographs and reproductions has its dangers. The older art historians,

* One justification of the recent surfeit of large-scale exhibitions of works of art is that they bring works of art to the historian, and facilitate comparisons.

aware that nothing stood between them and forgetfulness but intense study of a work of art and perhaps a hurried pencil sketch, gave to works of art when they saw them a close scrutiny which their successors, secure in the knowledge that a photograph is obtainable, are apt to neglect. The seriousness of this lies in the fact that nothing can replace study of the original work of art. It is easy to realise that no photograph can give a full idea of any work in three dimensions such as a building, or a piece of sculpture in the round; while in the case of a picture, not only is colour absent, but there is apt to be a distortion due to reduction in scale, which is very disturbing. It is not going too far to say that a work known only in a photograph is scarcely known at all; and that the value of the photograph is primarily to serve as an *aide mémoire*, to revive in the mind knowledge gained by previous study of the original, or to serve as a preliminary to study of the original.*

Assuming however that the art historian has his material in the shape of a work of art before him, his first step must be to find out as exactly as possible what is present in that work of art. This would

* The use of a lantern and slides may diminish the difficulties due to change in scale; and the cinematograph is potentially a valuable means of enabling a three-dimensional object to be studied from every aspect. So far, however, the cost of making adequate films has proved a serious obstacle to the use of the cinematograph for study in art history.

seem to be too obvious to need mention; yet strange to say it is a stage in investigation most often scamped, invariably to the detriment of all subsequent stages. Naturally the order in which the different elements in a work of art are studied will differ with individuals; but an essential preliminary to detailed study is to obtain a general impression of the work as a whole. A work of art is not merely an assemblage of parts; its essence lies in the ordered relation of those parts. The first impact of a work of art on the spectator, before he has become occupied with detail, is of the greatest value for enabling this relation or system of relations to be grasped. How much this first impression will yield depends on the experience, knowledge and sensibility of the spectator; and it may well be profoundly modified later. But received as it is when mind and eye are comparatively innocent, it has a unique value, and often yields information and enlightenment of a kind not easily to be acquired later.

At an early stage in the investigation, the physical constitution of the work of art must be studied. It is essential to realise that the creative impulse of the artist is conceived in terms of and finds expression in a specific material. The conception of a work of art is not something which attains its final shape *in vacuo* and is then embodied in some arbitrarily chosen medium. From the beginning conception and material act upon each other, the conception shaping the material through the hands of the artist,

the material controlling the ultimate form in which the conception is expressed, to the extent that the conception may be adapted and modified as work proceeds by discovery of limitations and possibilities of the material. Moreover discovery of a new material may provoke new conceptions in the mind of an artist; or new ideas bring new materials into use.

So it is with technique. The influence of this upon the form of a work of art is distinguishable from that of material; since though technique is ultimately dictated by material, a wide range of technical methods is possible in dealing with a given material. As in the case of material, style and technique influence each other. The discovery of new technical methods may profoundly affect style, as in the case of the development in the use of oil as a medium for painting in fifteenth-century Flanders, which opened the way to all the wide-ranging developments of the sixteenth and later centuries. Similarly, changes in style due to some other cause may inspire developments in technique to meet the artist's needs.* But the relation of the form of a work of art to material and technique, though so close, is elastic. Change on one side may not immediately or necessarily involve change on the other, and may work itself out through

* An excellent summary of the relations of style with material and technique is given in D. V. Thompson, *The Study of Medieval Craftsmanship*, Bulletin of Fogg Art Museum, Oct. 1934.

obscure channels. For example, an artist may re-
produce in one material forms characteristic of
another. This may either be a deliberate *tour de
force*, as when a sculptor in marble imitates metal
or textiles, as in much nineteenth-century tomb
sculpture; or it may occur when a new material
comes into use, and conventions based on an earlier
material are perpetuated. Early examples are the
imitation on clay vessels, moulded by hand or on
the wheel, of the pattern left as the result of the
earlier process of moulding clay inside a basket;
and the imitation in pottery of the shapes of hide
vessels. An analogous case in the Middle Ages was
the adoption in Gothic architecture of forms which
had their origin in the use of wood; and in fifteenth-
century Italy, the increased elaboration and finish in
the carving of marble, following on the develop-
ment in the use of bronze by Donatello and
Verrocchio.

To realise the importance of material and tech-
nique in relation to style, it is only necessary to
compare similar work carried out in different
materials. In a marble figure by Donatello, such
as the *St George*, may be seen the broad sim-
plified planes which marble readily yields; in his
St Mary Magdalene, in wood, he has utilised the
broken surfaces and abrupt transitions to which
wood lends itself; while in his bronze *Judith and
Holofernes*, the tensile capacity of the metal has
been exploited. Or compare the painting of a head

by (say) Filippo Lippi, with its limited range of tone values, and the lack of fusion in modelling imposed by the use of tempera, with the greater range and greater subtlety of handling made possible by Titian's use of oil glazes; or, again, with the transparency of Rubens' shadows, and his rich sweeping impasto, made possible by the use of oil.

Such examples as these could be multiplied endlessly; and make it evident that knowledge of materials and of technical processes in the arts is essential for the art historian, if he is to gain full understanding of the character of a work of art. But technical knowledge has a further importance. It makes it easier for the spectator, in contemplating a work of art, to identify himself with the artist, and grasp the working of his mind; and by presenting the work of art to his mind as in part the solution of a technical problem, the adjustment here and now of means to an end, helps him to realise the work as a living whole, rather than as a dead specimen.

From the foregoing, it would appear *prima facie* that an artist would be particularly well equipped to become an art historian. In fact, apart from his normally lacking the training and equipment required by an historian of any type, his being an artist is likely to be a serious handicap. For him a work of art exists only in so far as it embodies his own standards of artistic right and wrong; and the better and more positive he is as an artist, the more

likely he is to lack the detachment and power of balanced judgment which would enable him to estimate what a work actually contains. Only very rarely are these qualities and the necessary intellectual aptitudes combined with vigorous creative power, as in Sir Joshua Reynolds. When this is the case, the ideal art historian may emerge. Normally, however, the artist who has become a considerable art historian is an artistic mediocrity whose training has given him technical knowledge to add to other kinds of ability.

In studying the physical constitution of a work of art, a most important matter is to consider how far it coincides with the state in which it finally left the artist's hands. There are really two problems here. Allowance has not only to be made for such things as dirt of all kinds and additions made by later hands, which can theoretically, and in most cases practically, be removed to reveal the original work; but also for changes due to chemical or physical modifications in structure, including decay, which can rarely if ever be nullified. Thus the art historian has to do two things. He has either mentally or with the help of a restorer to take away accretions from the work of art; and he has out of experience or knowledge to make allowance for any fundamental and irreparable changes which may have taken place. In this second task, discreet and skilful restoration can often be of great service. If, for example, a considerable area of a painting has

been damaged, the covering of the damaged area with a tone in harmony with what remains, and the indication thereon of any details whose former existence can be safely deduced, will greatly help study of what is left of the original, by reducing the distracting power of the damage. Again, where chemical changes have drastically altered the relation between the lights and darks of a picture, the retention or use of a toned varnish may definitely help the spectator to grasp the original intention. It is too often thought that the relentless removal of everything except original work is an advantage. Very often, additions thereto, if the fact that they are additions is readily discernible, may be a great advantage in helping study of what is left of the original. But the fact has to be faced that in many cases a work of art can never be seen as the artist intended it to be seen. This may not always be a disadvantage, but it must be taken into account.

In the investigation of the physical constitution of a work of art, the application of scientific resources is potentially very valuable. Until recently most of the results obtained were meretricious, since the problems to be investigated had not been clearly stated, nor had the possibilities and limitations of the methods used been carefully enough considered. Today however work is proceeding in several centres, on much more deliberate and carefully planned lines, which has already yielded information of the highest interest. It is well to

emphasise however that it is only in connection with the material composition of a work of art that the scientist can make a contribution to art history. For him the work of art is, and must remain, merely a complex physical substance submitted for analysis; on its qualities as a work of art no method of investigation yet known to science can throw light. In other words, the position of the scientist is to furnish part of the raw material of fact on which the art historian can in conjunction with other facts exercise his judgment.

The means of investigating works of art at present in use by scientists cover a wide field. They include those employed in all branches of optics, including colorimetry, and the various radiations, notably X-rays, infra-red rays and ultra-violet light; all the microscopic and analytic methods of the chemist, including spectrographic analysis; and certain methods of the physicist, notably those relating to the strength and behaviour of materials.* A great deal of this scientific investigation has been applied not only to the physical constitution of works of art but to the problem of their restoration and conservation; and so more directly concerns the collector or art gallery director than the art historian.

* A valuable survey of the methods and possibilities in the investigation of paintings is given in Rawlins, *The Physics and Chemistry of Paintings* (Cantor Lectures, 1937, Royal Society of Arts). *Mutatis mutandis*, the information here given can be applied to other arts.

So far microscopic and analytic methods have been most systematically applied to the identification of pigments used in painting, though they are being extended to the investigation of other substances. By their means certainty is being slowly reached concerning the materials available in the past and the methods of their use. Obviously however the greatest care must be taken that the sample of material investigated comes from an original part of the work of art and not from some later addition. In the allied field of how various pigments were employed, less progress has been made, and the problem of, for example, mediums and varnishes still needs much investigation. One recent branch of investigation, the measurement of colour, holds much promise of usefulness to the art historian. By the use of the tintometer it is possible to gauge the actual colour of a surface under a layer of dirt or discoloured varnish, and so without removal of the latter get a clearer idea of the colour of an object than was formerly possible; and by measuring the changes in colour of pigments known to have been used in the past, it may be possible to estimate the original appearance of pigments now irrevocably changed.

In many of these investigations a crucial difficulty may be that of obtaining suitable samples of material; since owners of works of art and heads of galleries and museums are naturally reluctant to have pieces chipped off their possessions. Something may

be done by taking samples from inferior works of the same provenance and period; but too little is known concerning variations in the practice of different workshops to make argument from one case to the other wholly safe. It is therefore of some importance to develop the use of analytic methods which do not require the taking of samples, and for this, the use of various types of radiation seems to offer considerable possibilities.

At present however the chief use of the X-ray, ultra-violet ray and infra-red ray has been in other fields, that of probing beneath the surface of a work of art and of ascertaining the presence of additions to the original material. Until quite recently however the methods used were very rough and ready, which yielded results much exploited in the popular press, but whose meaning and significance were obscure, and which lent themselves to various types of charlatanism. Today by such means as systematic variation in kilo-voltage in the case of X-ray, and in the length of exposure joined to careful record of results, a vocabulary is being built up which enables results to be intelligently interpreted. Even so, the range of discovery is still strictly limited. For example, the presence of retouches or additions to a work of art may appear very clearly under the ultra-violet ray, though nothing very much more can be deduced, such as the age of the additions. Similarly, the X-ray may reveal certain facts as regards the underpainting of a picture; but it will

not reveal all the facts. These need discovery by other methods. An interesting example of such limitations is the case of the *St Mary Magdalene* by Rogier van der Weyden in the National Gallery. This was obviously part of a larger picture which for many years was thought to have been a Crucifixion. Some years ago, the picture was X-rayed, and underneath the comparatively modern black background appeared the clear image of the interior of a room, with the figure of a man and some drapery. Part of the background was then removed, when it was found that the material which gave a perfect image on the X-ray screen was in fact a 'ghost', a painting that had been rubbed down so that little or nothing was visible to the eye. Thus the X-ray conclusively abolished the idea that the picture once formed part of a Crucifixion; but gave no information as to the condition of what was under the background.

In another case, in another gallery, the limitations of X-ray (or perhaps of those who used it) led to disaster. The X-ray revealed an underpainting differing somewhat from the painting visible to the eye. On the unwarrantable assumption that the latter must be an addition by a later hand, it was removed; only to raise the strong presumption that what had been taken away was the final version of the artist himself, to lay bare his first approach.

These examples and many others emphasise that no one means of investigation in the répertoire of

the scientist is itself adequate or final. But it is necessary to reiterate that even if he brings to bear upon a work of art all his batteries, he can only provide information as to physical condition; and that in the present state of knowledge, there is certain information even in this limited field that the trained human eye or touch can more readily and certainly discover than any other instrument, while the interpretation of results still depends on the human intelligence.

One small part of the general field in which scientific investigation may be particularly useful to the art historian is in connection with signatures, dates, inscriptions, and heraldic and other devices, to help in determining both their character and authenticity. Microscopic examination may, for example, suggest that a signature or inscription has been added to a work long after it was completed; the ultra-violet or X-ray may reveal alterations of a signature from an undistinguished into a distinguished name, make clear illegible parts of an inscription, or show the original beneath an inscription which has been renewed, and establish the trustworthiness of its meaning, if not of its material. But examination of signatures, inscriptions and similar things calls for more than scientific means. These may make the forms decipherable; but interpretation of their meaning calls also for the apparatus usually required for such purposes, including some skill in palaeography and a knowledge of

customary forms of lettering, contractions of words and so on, as well as a knowledge of heraldry, and of devices such as the *imprese* used in Italy.

The importance of the whole matter is greater than it is often supposed to be. Quite apart from their bearing on authenticity and date, material such as inscriptions frequently gives valuable information concerning the occasion which brought a work of art into being, and the circumstances surrounding its production, which is difficult or impossible to obtain elsewhere. For example, it may be valuable in ascertaining the exact subject of a work of art. It is fashionable today to decry the importance of subject, and to say that works whose interest depends wholly or in part thereon are literary rather than pictorial and plastic. This may be so; but it does not alter the fact that the subject —the idea or conception aroused in the artist's mind by some experience, usual or otherwise—is an integral part of the work of art, and has its influence upon the form of the work. Thus, for the art historian, subject is one of the factors he must take into account in trying to ascertain why a work has taken a particular form.

It has to be remembered too that an artist was and is not always free to choose his own themes, which may often be dictated or elaborated by his patron; and it then became a definite artistic problem to throw these themes into pictorial or plastic form. For example, the design of the famous por-

trait of Jean Arnolfini and his wife by Jan van Eyck, in the National Gallery, was not determined solely by the choice of the painter; but incorporated certain traditional elements as regards gesture and accessories, appropriate to the solemn plighting of a troth in the Middle Ages.* So, for the art historian, a careful study of subject is necessary, even though the work is looked at purely as a pictorial or plastic creation. This need is all the greater when a work of art is to be studied, not only as a work of art, but as a document which throws light on other sides of man's activities, to provide material for other branches of learning. To the rest of his equipment therefore the art historian must add some knowledge of iconography in the widest sense of the term; travelling far beyond the question of identifying personalities into such matters as costume and armour, the distinguishing emblem and apparatus of saints and heroes, and themes both secular and religious which are traditional or drawn from specific literary sources.

* Panofsky, *Burlington Magazine*, March 1934, p. 117, gives a brilliant exposition of the iconographical significance of the painting and incidentally of the importance of subject in a work of art.

§ iii

THE problems which next arise in the course of examination of a work of art are more difficult; since they are concerned with characteristics which are fundamental to the work as a work of art, but are incapable of being exactly measured or scientifically tested.

To indicate the nature of these problems, take the case of a painting. Here, the character of the design, the drawing and the colour are the chief elements to be considered. Design may be roughly defined as the system on which the constituent forms in a painting are organised. Among questions which have to be decided is whether the design is conceived primarily in two dimensions or in three; and whether the forms in the picture are independently defined and are related by their placing in the picture, or whether their identity is obscured by their being bound together into larger units by light and shade. Another important matter, in the case of pictures in which the third dimension is involved, is the main system of arrangement; whether, for example, the constituent forms are arranged chiefly in planes parallel to the picture surface, or recede from it at varying angles; and whether the

grouping of the forms is self-contained and centri-
petal, so that the edges of the painting form a
natural boundary, or whether it is centrifugal in effect,
carrying the eye away from the centre, and imply-
ing extension beyond the edges. As examples,
contrast the *Annunciation* by Simone Martini in the
Uffizi Gallery, in which the design is primarily
two-dimensional, with Raphael's *School of Athens*,
in the Vatican, in which the design is primarily in
terms of the third dimension, with its main planes
either parallel to the picture plane or receding from
it at right angles. In the *School of Athens*, also, the
construction is such as to concentrate attention
within the picture, and to drawing the eye from
the edges towards the middle; while in Rubens'
Kermesse in the Louvre, the planes and accents are
so arranged as to have a dispersive effect.

Different uses of light and shade in relation to de-
sign may be seen by comparing the *Pan* by Signorelli,
in the Kaiser Friedrich Museum, Berlin, with (say)
Rembrandt's *Pilgrims of Emmaus* in the Louvre.
In the Signorelli, the chiaroscuro is strong, but is
mainly directed towards the firm definition of the
individual forms. In the Rembrandt, the individual
forms are merged in enveloping light and shadow,
which builds up the series of bosses and hollows
which constitute the design. The examples quoted
are simple and easy cases; but it will be realised
that reasonably exact analysis of the character of a
design may often be complicated and difficult.

In drawing, which is concerned with the methods of expressing forms, and the statement of their relations, the kind of problem involved is indicated by comparing a page from the sketchbook of the twelfth-century architect, Villard d'Honnecourt, in which line alone is used, and the form is two-dimensional, with a drawing by Raphael or Ingres in which little but line is employed, but by variations in quality and stress, and by overlapping of lines at the junction of forms, three-dimensional character is given. Again, in certain drawings by Michelangelo line and chiaroscuro combine to give marked sculpturesque quality, the line providing a definite contour enclosing the form. In contrast, in many drawings by Rembrandt, the main masses are stated in terms of light and shade only, line being used to emphasise direction, or the relations of forms; while in the majority of the drawings of Seurat, strong chiaroscuro is employed, without line.

In considering colour, it is not enough merely to study the tints which have been employed; the way they have been used, and the purpose they are intended to serve must be considered. For example, the main function of the colour may be to form a decorative pattern, either largely independent of the arrangement of forms in the picture, or arranged to emphasise that arrangement; in which case both the choice of colours and their combination give room for marked differences between different pictures and different painters. Sometimes, as with

the Impressionists, colour may be chosen and handled primarily to suggest light and atmosphere; or again, as with Cézanne, the aim of colour variations may be mainly to define form, and to establish relations between forms. Naturally, such different potential uses of colour may be combined; but any adequate study of a painting must seek to disentangle them.*

With the information concerning a work of art gained by systematic and intensive examination of the type described, the art historian is ready for a new synthesis. He has first to see as a unity all the separate elements he has distinguished, and to realise them, not as a number of isolated facts fortuitously brought together, but as completely interdependent. Then he has to be ready to seek to understand what the artist has sought to convey. It is in these two last stages that the emotional approach must combine with the intellectual, and ultimately transcend it. The work of art should emerge as something in which the whole is greater than the sum of the parts, the creation of one mind and hand. It is this quality which marks out an original work from even the most skilful copy. To the trained and sensitive mind, the basic unity

* The use of photographs and monochrome reproductions of works of art has had unfortunate effects in the importance of colour being under-estimated. It is often the most difficult of all characteristics to imitate; and is often therefore the decisive factor in distinguishing the work of one artist from another.

of the original will become increasingly apparent; while the copy will become more and more evidently an assemblage of parts. It is sometimes said that intensive study of detail in a work of art is liable to spoil the capacity to realise it as a whole, and to mar the power of aesthetic enjoyment. Perhaps so, occasionally; but little harm will be done by spoiling so feeble a plant, while more robust capacity will flourish on increased knowledge. The argument is analogous to that which deplores hard practice and severe training in an artist, lest originality be crushed. It has justly been emphasised that there is, besides a cognitive, an intellectual factor in aesthetic experience, which is often neglected but never successfully explained away.*

* Listowel, paper read before the 9th International Congress of Philosophy, 1937.

§ iv

T HE ground to be covered in the examination of a work of art, and the various methods which may be involved, have been sufficiently discussed, to indicate that the process may well be long and complicated.

This, however, is only a first stage. All that has been done is to determine as far as possible what is present in the work of art concerned. Now comes the more difficult business, that of placing the work in relation to other works of art, in order to determine its period, its place of origin, its author and its position in relation to his other work. In this lies the whole art of the connoisseur, which has been defined as, 'the comparison of works of art with a view to determining their reciprocal relations'.* It is important to realise that this 'placing' of a work of art is not an end in itself, except from the point of view of the art market. But it has a double value. It is an important step towards understanding a work of art, since the language of form and colour, the main constituents of the visual arts, may be universal, but every artist with an indepen-

* Berenson, *Study and Criticism of Italian Art*, 2nd series, p. 122.

dent personality uses it differently; and the comparison of any particular work with others by the same hand, or coming out of the same school and period, helps to give familiarity with the vernacular of an artist, and so make easier realisation of what he has to communicate.* Moreover, until the period, place of origin and authorship of works of art are determined, art history cannot exist. As Morelli† puts it: 'It is absolutely necessary for a man to be a connoisseur before he can become an art historian.'

Others have written in detail on the problems and methods of connoisseurship.‡ Here it is only necessary to touch on certain aspects of them. In the placing of a work of art, the three main sources of information are contemporary or early documents, including signatures and inscriptions on the work itself; written and oral tradition; and works of art themselves. Of these, the works of art are infinitely the most important; but it is convenient to consider the others first.

* In the words of Goethe:
 'Wer den Dichter will verstehen
 Muss in Dichters Lande gehen.'
† *Italian Painters*, transl. Ffoulkes, I, p. 15.
‡ A pioneer work, which has inspired most modern methods of critical investigation, is the above-cited work of Giovanni Morelli. A masterly essay on the subject is by Berenson, in *Study and Criticism of Italian Art*, 2nd series. Richard Offner's *Outline of a Theory of Method* (in Studies in Florentine Painting) is valuable for its insistence on the more impalpable and subjective elements in connoisseurship.

In connection with contemporary documents, in addition to the difficulties which confront every historian, such as those connected with questions of authenticity and good faith, the art historian has some special problems. The first is to be certain that the work of art under consideration is actually the one to which a document refers. This is often a matter of immense difficulty, since in such documents as contracts only the briefest description of a work may be given, and the finished work may differ materially from even this description. Again, it is difficult always to be certain that at some point in its history an early copy or version has not replaced an original; and a document, even a photograph, will be little use in distinguishing the two.* It is this necessity for identifying works with those mentioned in documents which justifies the long and laborious research into the history of a work of art, which the art historian often has to take; attempting to trace through catalogues of private collections, sales and exhibitions, and through early guide-books and similar sources, the movements of

* A case in point occurred a few years ago in connection with a portrait by Sir Joshua Reynolds. The owners, who were descended from the sitter, held Reynolds' receipt. Questions were raised as to the authenticity of the painting, and ultimately it was discovered that at an early date the original had passed to another branch of the family and a replica had been put in its place. This was a case of genuine mistake; but the deliberate substitution of a copy plus a document for an original is not unknown.

the work since it left the owner's hand, conscious that at any moment a fatal gap in the sequence may appear.* But even with a perfect pedigree, there is the further difficulty that the artist paid for a work of art was not always the artist who produced it. The studios of such painters as Rubens and van Dyck were organised for production on a large scale, and contained a number of skilful assistants; and the holding of a receipt from the head of the studio, joined to conclusive proof that the receipt refers to a given picture, does not necessarily make it certain that the head of the studio put even a touch on that picture. So it is with signatures. Assuming that the signature has been fully tested, and is undoubtedly contemporary with the work; assuming also that it is exactly similar in character to signatures on completely authenticated works; nevertheless, in the case of such a painter as Giovanni Bellini, this signature amounts to not much more than a studio trademark, like the famous Schlangel or snakelike dragon, with which the productions of the shop of Lucas Cranach were marked.

Other types of documents often used to trace the make of a work of art are preliminary designs whose authorship is independently known, and engravings after a work. Sometimes they may be

* The art historian whose main interest is architecture here scores over his fellows. But even so, accounts referring to one building have sometimes been taken as referring to another.

most helpful; but their use has obvious dangers. A work may have been made by one artist from the design of another; pictures have been made from engravings, as well as engravings from pictures; and even when the engraving is derived from a picture, the intervention of a copy made by an alien hand for the use of the engraver may complicate the situation.

Written and oral traditions are even more open to suspicion than contemporary documents. The founder of a tradition has often been proved to be careless, to have made a mistake, or to have been biased, especially when he was remote in period or time from a work of art to which he refers;* while the opportunities for subsequent garbling are immense. Tradition may give a useful lead to an enquiry, especially in tracing the history of a work of art; but it can rarely be accepted as conclusive evidence of the authorship of a picture. An exception is where the traditional name is an obscure or otherwise unknown one, which carries with it neither honour nor market value.

There remains as material for the connoisseur works of art themselves, which provide in the legal sense of the term 'best evidence', since that evidence is first hand and direct, and if correctly read outweighs any other type. The difficulty lies in the reading, especially if the evidence has been over-

* Vasari, with all his industry and knowledge, is a case in point.

laid by accretions or removed by damage and decay. But assuming that allowance can be made for excrescences and defects, both material and style are available for placing the work of art. Naturally, the wider categories of period and place of origin are likely to precede consideration of authorship. In trying to establish these, not only is a wide general knowledge of the type of work in question required, but wide knowledge of quite another type. For example, the date of the discovery or availability of certain materials establishes a limit as regards period in one direction. If, in a picture thought to be of the seventeenth century, the presence can be securely established of a pigment not known until the nineteenth century, a strong *prima facie* case for error is established. Similarly fluctuations in the supply of ivory in medieval Europe were such, that its use at certain periods practically ceased, and works of those periods are most unlikely to exist.

Less convincing, but often valuable evidence as to provenance, is the fact that certain materials are found or used only in certain places, or for some reason or other are as a rule employed only by certain peoples. For example, in panel painting oak was normally used in Northern Europe, lime and poplar in Italy; and since alabaster had its chief centre of production during the Middle Ages in England, carving in alabaster is a peculiarly English art.

Subject may also be a guide to period and pro-

venance, since some iconographical themes only appear after a certain date or are chiefly used at certain times and in certain places.* Costume, again, may be most useful for suggesting date and place of origin; though the possibility of a sitter wearing old-fashioned or fancy dress must be remembered, and also that the artist may have imitated earlier work. But the chance that an artist should have anticipated fashion is so small, that costume may be taken as almost certain proof that a work is not earlier than the date of the costume.† The evidence of physical types is also not to be despised, more especially in a naturalistic art.

Even more important is comparison with other works whose period and place of origin are known. Here, the whole question of style is involved. Technique has to be investigated, since some methods of work appear only after a certain date, such as the use of the drill in sculpture, while others fall into disuse, as in the case of tempera.

Again, certain conventions in drawing and design mark certain schools at certain times, and, in the case of paintings, even certain kinds of general tone

* A description of a fourteenth-century Pisan work as Greek of the fifth century B.C. might have been prevented by recognition that the group represented the Virgin and Child.

† On this point, a correspondence in the *Burlington Magazine* (Jan. 1934, p. 40) is illuminating. The description of a sitter as the first Lord Baltimore was conclusively disproved purely by evidence from costume.

and certain harmonies of colour. A marked example is Byzantine work, much of it carried out strictly in accordance with the precepts laid down in manuals.

Whatever the evidence, however, it must throughout be used with great caution. The most remarkable similarities in character may appear in works widely separated in time and place of origin, where no question of deliberate imitation arises. Some grotesque animals in a fourteenth-century illuminated manuscript are extraordinarily like others engraved on metal which have been found at Ur.

From the foregoing, it is clear that the placing of a work of art calls for wide general knowledge, not only of the history of art, but of many other things as well. No one can hope to be a specialist over the whole field, or even to have more than a nodding acquaintance with much of the material he may have to use. But it is essential that the art historian should realise the extent of the ground he has to cover and should know where to turn for the information that he wants. Increasingly, the need in art history is for the organisation of specialised work, not only in art history, but in related subjects; and the pooling of its results.*

When the question of the authorship of a work

* An outstanding example of the possibilities is work done at the Warburg Institute, founded in Hamburg and now established in London.

of art arises, the art historian is inside his own field. Within the limits set by period and place of origin, the school or studio group to which the work belongs has first to be determined, and then the particular member of that group must be sought. Here, intensive rather than extensive knowledge is required. The essential basis of the work is the ascertaining, from the known work of artists, of characteristics which belong to them and to them alone; and the establishment of the presence of some or all of these characteristics in the work under consideration. That this should be possible is due to the fact that, almost invariably, some part of an artist's work becomes conventionalised, and he repeats certain tricks, peculiarities or methods. The nature of these depends on a good many factors, such as the artist's way of looking at the world, the purpose for which he intends the work,* the material in which he works, and his degree of manual skill. It has been argued that in working from nature, such conventionalising would not be likely to occur. But quite apart from the fact that completely to mimic appearance is impossible, even the most conscientious attempt to do so would only affect certain parts of a work. There are always passages which are less necessary than others to express the artist's aims and so can be treated more

* For example, sculpture intended to decorate a building may be very differently treated from sculpture in the round, and a ceiling painting from a small easel picture.

mechanically; there are others in which imitation of nature is less possible than elsewhere, or in which the fashion of the day, dictated either by the patron or the artist's training, need not be observed; and there are others again where the work is wholly or partly hidden, and so may be handled summarily.

Thus, there is plenty of opportunity for strongly individual characteristics to appear in a work of art, which will be all the more marked and easy to distinguish, in the case of a strong artistic personality. For example, in the case of painting and sculpture, the tendency for artists to standardise the treatment of hands is often a valuable means of identification. Such details as the proportions, the arrangement of the fingers, the treatment of the nails, and the indication of the bone structure, tend to follow a formula rather than reflect individual peculiarities.* Similarly, the treatment and arrangement of the hair, and the drawing of the eye and the ear, all easily tend to be formalised. The handling of drapery is particularly likely to reveal personal characteristics, also backgrounds; since in both cases it is easier for the artist to depart from what may be before his eyes, and subdue what he does to his general conceptions. Reynolds' idea of a generalised drapery obviously lends itself

* An analysis of various painters' peculiarities in the treatment of the hands will be found in Morelli, *Italian Painters*.

to establishing an individual convention. Colour again has too often been neglected in this connection. The use of certain colours, and especially certain combinations of colour, is highly characteristic of certain painters, and is often the least easily imitated of their peculiarities. Tricks in handling, the result of some special manual skill or dexterity and the use of certain tools, may similarly be most useful for identification purposes.*

In architecture, analogous personal traits make their appearance. The establishment of certain proportions between different parts of a building; the arrangement of the fenestration; the treatment of mouldings; even the choice of materials, with many other characteristics, may point to the artist concerned.

But in using such means of identification, caution is required. What appear to be personal peculiarities, especially to the inexperienced, are frequently characteristics only of a studio or a school, due to tradition or the influence of a dominating personality. Again, deliberate imitation of the mannerisms of an artist by a pupil or follower is always possible. Frequently, also, the less important parts of a work of art, in which conventional treatment is most likely to appear, were entrusted to assistants; so that they are valueless for indicating the presence of the master, and have no bearing

* See Berenson, *Study and Criticism of Italian Art*, 2nd series, for an analysis of these and other possibilities.

on whether the conception of the whole work and the carrying out of certain parts are by him.

Various ways of overcoming these difficulties exist. One consists in reinforcing the evidence of certain peculiarities by the continued search for others. The discovery in the work under examination of an increasing number of mannerisms which appear in work known to be by a particular artist, obviously increases the probability that it is by him.

More important and decisive is the way in which all the details of a work are brought together, the way the parts are related, and the weight given to various elements. This in itself constitutes a personal characteristic which may be decisive in identification. Insistence has been laid above upon the necessity of seeing and feeling a work of art as a whole—as something greater and more significant than the sum of its parts. It is through the work as a whole that the personality of an artist can often be most clearly felt, and his presence be firmly established. This explains the rapid and accurate judgments sometimes possible for experienced connoisseurs. Analysis has been made, either beforehand or swiftly and almost unconsciously at the time; and decision is reached by a synthesis which reveals an artistic personality, already familiar from previous study.

A complication in the process of identification is that the conventions and mannerisms of an artist, and the character of his artistic personality, may

vary throughout his career, with change in his intellectual and emotional make up, in his physical structure, and in the external influences which surround him. How far this is so, must be determined by analysis of work of different periods which can be dated securely by internal or external evidence, thereby establishing different groups of characteristics for each period.

This analysis gives material for the last stage in the 'placing' of a work of art: the determination of the point in an artist's career when the work under examination was carried out. Sometimes, however, datable work by the artist is so rare, or so unevenly distributed over his working life, that no sure test as to period can be established. In this case, internal evidence may be some guide. The work of a young man generally possesses certain characteristics such as clear dependence on earlier masters and lack of unity, which distinguishes it from mature work. Further, if to the ascertained influence of a particular artist or school can be joined knowledge of when the painter came under that influence, the probability of reasonably accurate dating is increased.

The advantage of this pinning down a work of art to a particular date in an artist's career has sometimes been challenged. The answer is similar to that which justifies study of all the circumstances surrounding the creation of a work of art; that knowledge of the work of one period properly used

may enrich and illuminate the study of that of another.

Throughout the business of ascription and dating, the difficulty is to keep a sense of proportion. Too often the mere excitement of the chase, quite apart from ulterior motives inspired by ownership or marketing considerations, leads to evidence being strained or twisted to establish that A. was author of a work, when at best only a probability that he is so can be established. It is particularly necessary to be on guard against the trap lurking in the question, 'Well, if it is not by A., by whom *is* it?' There are many works of art the conditions of whose production practically prohibit definite attribution. Where, for example, two considerable artists similar in outlook are in close contact, as were Titian and Giorgione at one period, their work may have so many elements in common that distribution between the two can only safely be made on the basis of documentary evidence. Again, there is the case of work produced with the help of competent assistants. Where, in certain paintings, did Rubens leave off and van Dyck begin, or, in certain buildings, what were the respective shares of Vanbrugh and Hawksmoor? In general, too little account is taken of the methods of production of works of art up to the beginning of the nineteenth century. Behind the known name lies the anonymity of the workshop, which was the productive unit at least as often as the individual. So, to trace a work to a

particular studio or group of artists may be all that is possible; and such uncertainty of attribution is far better than the appearance of a certainty, which is unattainable and therefore false.

Finally, it is well to heed Coleridge's warning given in one of his letters, which applies as well to the visual arts as to poetry.

'It will not be by dates that posterity will judge of the originality of a poem; but by the original spirit itself. This is to be found neither in a tale, however interesting, which is but the canvas; no, nor yet in the fancy or the imagery—which are but forms and colours—it is a subtle spirit, all in each part, reconciling and unifying all. Passion and Imagination are its *most* appropriate names; but even these say little—for it must not be merely Passion, but poetic Passion, poetic Imagination.'

§ V

I N the next stage of the consideration and study of a work of art, the art historian parts company with the connoisseur, and embarks on problems peculiarly his own; those connected with explaining how and why a particular work or group of works produced at a certain period and place possess certain characteristics which together constitute its style. For this, he is at present less well placed than in the earlier stage of his work. For the study of the origin and development of style, material has not been accumulated, nor a technique developed on the same scale as for the work of the connoisseur; partly because the study involved covers so wide a field, partly because co-operation among art historians themselves, and of art historians with others, has not been carried sufficiently far. Consequently, the nature of the problems to be solved is not always clearly understood, and the solutions offered are often singularly tentative and inconclusive.

The term 'style' used in connection with a work of art implies the presence of three main groups of characteristics: those peculiar to the artist himself; those which belong to the immediate circle of which he forms part; and those which are common

to a particular period or particular area in which he worked. In strict logic, the three groups can scarcely be separated since the artist's personality is due in part to his environment, which in turn may be affected by his personality. But in practice, the division is convenient.

These characteristics are not only those which mark the component parts of a work of art; they include the way in which those parts are related. This relation may vary quantitatively, that is, the same style characteristics may be combined in different proportions; or qualitatively, in that different artists may use the same style characteristics for different purposes. Thus, colour may be used purely as decoration, independently of form, or as a means of defining form. In such a case, a difference in style results.

The elements in a work of art whose character or relation determines style naturally vary with the art concerned. Invariably they must form part of the work of art as a work of art. To take a simple example, a signature or inscription may be an integral part of a design and so become a style characteristic as in the case of much Far Eastern painting; but *qua* signature or inscription it is irrelevant to style. It is also important to realise that in no art is material itself a style characteristic; nor is subject, in the arts into which it enters. But both may have a decisive influence on style.

The material in which an artist works always

has its characteristic structure, and through this imposes its own technical limitations. The extent of these varies with the artist's skill, the state of knowledge at the period, the progress of scientific invention and similar causes; and it is the particular technique used within these limitations which constitutes a style characteristic.

The relation of subject to style is less simple. In painting, for example, subject may affect, and frequently has affected, design, drawing and colour; and by influencing choice of material has affected technique. But there is no necessary connection between subject and these elements. On the contrary, it is frequently the case that given the same subject, different artists will produce work differing completely in style; while it is quite possible to conceive of works exactly similar in style of entirely different subjects.

Completely to account for every style characteristic in a work of art might well involve a survey of the whole history of the human race, and raise difficult questions concerning the nature of human personality, and the method of its expression in a work of art. Sometimes, the individuality of an artist is so great, that his work breaks away from all current ideas and practice and makes it appear almost unrelated to the thought and work of his age. Mercifully, the number of artists whose personality is so overwhelming that its influence on style transcends

or obliterates the action of other forces is very small. Generally, even the most original mind expresses itself within the framework of style which belongs to a particular period and place; and the art historian is therefore justified, in the first place at least, in concentrating attention on the influences which have determined the character of this framework. These fall into two groups: those connected with elements in the work of art itself, such as material and subject, concerning which something has already been said; and those due to forces external to the work, such as race, geographical situation, religious, political and economic environment and, last but not least, current ideas and theories concerning the arts. Clearly, the ways in which such influences work may vary widely. They may act directly to create a new style element or modify an existing one; they may act indirectly, by affecting the action of other influences, such as the transmission of style from one place to another; and in both cases they may be positive and formative, or limiting and restrictive. Even when the forces at work have been disentangled there remains the crucial difficulty of estimating their relative weight and importance, though here the art historian is in no worse case than any other type of historian.

§ vi

To illustrating and making clear the kind of problem which the art historian has to face in considering how and why a work of art has taken a particular form, the following survey of the main changes of style in Western European painting is directed. Its purpose is not only to indicate what those changes were, but to suggest the forces which brought them about; and so to make clear the complexity and wide range of the art historian's work, even when applied to a limited field.

A possible method of treating the subject would be to take a number of possible style determinants, and attempt to trace their influence or lack of influence on European painting. This method has serious drawbacks, however. One is that some important influence might be neglected, since there is no *a priori* method of establishing its existence; another, that no comparison of the relative importance of various influences at different times and places can be made.

Consequently, in what follows, certain major changes in style are considered in historical sequence, and the attempt then made to disentangle and evaluate the forces which brought them about; so

developing some conception of the kind of influences, and of their comparative weight, for which search has to be made, in considering any specific problem of style connected with some particular work of art.

The first great school of painting to appear in Western Europe after the break-up of the Roman Empire is that which centred in the court of Charlemagne and had important fields of activity in north-eastern France and at Tours. Knowledge of its work is almost entirely derived from illuminated manuscripts, in which two distinct though related styles appear: one deriving from the realistic, impressionist, paintings of the later Roman Empire, the other mainly based upon Byzantine and Near Eastern exemplars. Political conditions clearly played their part in this Carolingian Renaissance. It is obvious that the development of the arts only becomes possible on the attainment of a certain level of political, social and economic stability; and this Charles the Great established. The tendency however is to fix this level too high. It has been ingeniously argued,* on the basis of conditions in fifteenth-century Italy, that too great a sense of security of person or property breeds a slothfulness unfavourable to the activity of mind and imagination on which the arts live; and this view may be supported by reference, not only to other periods of European art, but to the conditions under which the art of primitive peoples is produced. Of greater

* Sir Charles Holmes, *The Tarn and the Lake*.

importance than absolute level, is the speed and character of changes in political and economic conditions. A sudden disaster such as the Black Death, by creating a sense of uncertainty, had more influence on the arts than a permanently low standard of life and political organisation.

In any case, political, social and economic conditions are not direct determinants of style; they are only important in so far as they affect the working of other influences. The Carolingian period affords a good example of this, in that political relations with Rome and Byzantium encouraged cultural intercourse, and possibly brought artists, and certainly works of art, from those centres to the court of Charles the Great. Geographical conditions acted in the same way, and were at least as important; and since their influence has been a continuing one, it is well briefly to analyse their character. Through the heart of the Carolingian Empire ran a great belt of territory from the Low Countries in the North to the Apennines in the South, including on the west the valley of the Rhône, on the east the valley of the Rhine. Through this ran, and run today, the main highways linking northern and southern Europe; and into these ran at various points the main routes both by land and sea, from east and west. The roads from north to south found no serious obstacle in the Alps, for the most part crossing them at their extremities, circling Switzerland, and meeting in the flat northern part

of the belt, today north-eastern France, Belgium, and the Lower Rhine valley, which thus became an all-important centre for concentration and distribution.

Broadly speaking, whatever the course of political events, intercourse between north and south Europe has been continuous through this great belt of territory; and consequently, cultural exchanges between Italy and northern Europe have never been interrupted. The routes leading westward from this belt have also remained open; though their cultural importance is relatively small, since the movement along them has mainly been outward. With the routes to the East, however, the case is different. Along them, powerful influences on art might travel; but they were frequently closed or obstructed, and so eastern influence on European style has been spasmodic and irregular, both as regards time and place. In the time of Charles the Great, however, the routes to Byzantium, Syria and Egypt were all open, including not only the sea routes through Italy, but the one coming overland through South Germany. Also the Byzantine Empire still had its outposts in Italy. So, all conditions were favourable for a concentration of Roman, Byzantine and Near Eastern influence on Carolingian art.

But Carolingian manuscript illumination is more than an eclectic mingling of transplanted style characteristics. It is possible to regard it as a series of provincial versions of more metropolitan arts;

but it has distinctive qualities of its own. Chief among these is a tendency to conventionalise detail, especially in the treatment of drapery, and to the use of abstract ornament, in both cases with a decorative aim. Quite distinct from this process is the use of certain abstract and geometric motives derived from the so-called Celtic manuscripts, whose chief centres of production were in North Britain and Ireland; and this may be directly due to the influence of race. The connection between race and style in art is still obscure, and merits detailed examination from ethnologists; but it seems reasonably clear that the Nordic is less interested in the human form, and in human relations, than the Mediterranean man; and in his art tends towards the use of abstract pattern rather than of realistic and dramatic statement. In the main centres of Carolingian art, Nordic elements were presumably strong; and it is reasonable to trace to their influence the abstract, decorative elements in Carolingian painting.

The influence of climate may however have been a contributory factor. Painters in northern Europe have necessarily been less familiar with the nude human figure than those of the South: while the more variable conditions of atmosphere in the North have provided a wider range of material for landscape painting. In the North also, climate has been unfavourable to the use of *buon fresco*, whose technical character has exercised much influence on

style in Italian painting. Thus, as between North and South, climate has bred differences in knowledge and interest concerning certain material; and has influenced style by inducing comparative emphasis or neglect of certain elements in painting.

Romanesque painting, in which the next distinctive style appears, is composed of much the same elements as appear in Carolingian painting, but differently related to each other. Influence from Byzantine sources is still strong, since communications were still open; but appears less in subject and design, than in the long slender figures, the treatment of the drapery, and the strong colour enclosed within firm contours. The influence of realist, impressionist late Roman work has practically disappeared, reflecting the decline as a cultural centre of Italy, and of Rome in particular, at this period. Classical motives have also largely disappeared from the ornament, and abstract northern motives are more common.

But the difference between the Romanesque and Carolingian styles goes farther than a change in the balance of characteristics; and consists in these characteristics being more completely fused, so that the eclectic element disappears. The importance of this lies in the suggestion it carries with it: that in the Carolingian style lay the seeds of later developments, which took place apart from the operation of external forces, and point to style having, as it were, an inner life of its own.

The next important episode is the rise of Gothic painting in northern Europe in the early thirteenth century, and its developments up to the beginning of the fifteenth century. The skeleton of stone which came to form the characteristic Gothic building of the North severely restricted the amount of wall space at the painter's command; and so the manuscript as a field for painting increases in importance, and other techniques, notably those of painting on glass and panel, are developed. Moreover, in the Gothic workshop, many different arts were practised; and the influence of other arts upon painting becomes noticeable. The architect was supreme; and through the lines of his building he influenced profoundly the drawing and design of the paintings which were to decorate it; and conventions thus established reappear in manuscripts. Similarly, faced with the competition of painted glass, the painter had to raise the key of his colour, and silhouette his design more boldly; and both on wall and in manuscript he at times imitated the tracery patterns which the leading of windows dictated.

Thus, the decorative emphasis of Carolingian and Romanesque painting is present also in Gothic, and is confirmed and strengthened by the influence of the other arts. It is arguable also, that contact with the East, through trade and the Crusades, had a similar effect. The ban upon representation imposed by the Mohammedan religion diverted artistic

energy to pattern making, whose influence occasionally appears in Western work.

Another characteristic of Gothic painting, however, conflicted with this decorative emphasis: an increasing tendency to substitute description for symbolism, and so to develop narrative and realistic treatment, especially in detail. Consideration of the causes of this raises the question of the influence of the Church on art. There is no question that during the Middle Ages, the Church was the principal patron of the artist, either directly or through the piety of laymen; there is also no question that the Church used painting as a means of edification and of education, and that the incidents depicted, their iconography, even the positions they occupied in a church, were largely dictated by ecclesiastical authorities.* To the extent that the Church imposed on the artist the use of the concrete instance as opposed to the generalised symbol, its influence on style may be admitted; and so far as it permitted or forbade the representation of certain subjects and the use of certain material, such as the nude human figure, style was likely to be affected. But it is arguable that the influence of the Church in this way was comparatively small; and that the narrative, descriptive and realist elements in Gothic art were the result of an invasion of men's minds by

* There is, however, good reason to suppose that this dictation was less, especially in England, than such authorities as Mâle (*L'Art Religieux, passim*) imply.

a new conception of the Universe, in which man and the things of this world played an increasingly great part. While the conception held sway of the Universe as an organised cosmos with the Deity at its centre; while a form of thought ruled men's minds, which conceived of visible appearance as symbol and allegory of an ideal reality; while the ultimate end of man was regarded as the salvation of his soul, so long was painting likely to remain primarily decorative, symbolic and didactic, and to avoid description, narrative and realism.

But with the breaking in of humanist ideas, in the broadest sense of the term, the balance was bound to be upset, and changes in style to develop. So it is at least a tenable hypothesis that the direct influence of the Church on the style of Gothic painting was comparatively small, except in so far as it encouraged and stimulated, wittingly or unwittingly, a move in men's outlook in the direction of humanism. That it may have done so is indicated by an interesting episode in the history of Gothic painting, its connection with the medieval stage. In its later phases Gothic painting frequently took, not only its subjects, but their arrangement and setting, from the mystery plays; and the growing element in these of narrative and of realism in presentment would naturally affect the painter's work.

That humanist ideas in an inchoate form should have developed in northern Europe during the Middle Ages is not surprising. The classic tradi-

tion, both in letters and the arts, was moribund but far from dead. Classical texts were known and read, and there is some evidence of artists being in direct contact with classical art; scientific curiosity and interest in nature, stimulated by such influences as the Franciscan movement, developed steadily; and the movement towards autocratic kingship fostered the idea of man's control over his own destiny, at least in this world. The logical outcome of such changes in the medieval outlook was the outburst of realistic representation in the painting of fifteenth-century Flanders. The themes, both in choice and arrangement, belong to the Middle Ages; but the treatment is strikingly different. Realism in detail is pushed farther than ever before —perhaps as far as it has ever been pushed—and extends to every part of the setting; and the aim of decorative unity is sacrificed to that of a unity based on the use of perspective and careful observation of the effects of light, shade and atmosphere upon appearance. Behind everything is an attempt to paint a scene as it might have occurred, in terms of the world as the painter saw it.

To bring about this development, several factors co-operated with a change of outlook. Among these was the passing of patronage from the Church to the layman and, in Flanders especially, to the great merchants. The collector on a considerable scale of works of art begins to emerge, to whom alone the artist is responsible; and this opened the way for

the painter to express a new curiosity and a new knowledge concerning the world around him. Also, in fifteenth-century Flanders, painting became an art largely independent of the other arts. The only relic left of medieval interdependence is the influence on drawing and design in the earlier phases of Flemish painting of the sculpture in wood and stone which was a notable art round about Tournay. Later, the tables were turned, and Flemish painting was to suggest to sculptors in the Rhine valley and southern Germany their treatment of form.

Technical improvements also contributed to the new freedom. The legend concerning the invention of oil painting by the van Eycks is now exploded; but it is certain that their improvements in processes and in the quality of materials made possible greater precision and greater subtlety in handling, which markedly influenced style.

It is, however, in Italy that humanist ideas first found full expression in art. There, the classical tradition in art, in letters and in social organisation had remained very much alive; and, more than any other country, Italy had felt the continuous influence of Byzantium, both through its artists and its monuments. Racially, also, strains other than Nordic predominated in Italy; and so there is every reason to expect Italian painting to follow a different course from that north of the Alps.

This, however, is to neglect the influence of

communications between Italy and the North; and according to the relative weight of prevailing ideas, so style influences flowed north or south. In the late tenth and early eleventh century, when painting in Rome was at a low ebb, the residence there of the Ottonian emperors enabled the great school of manuscript painting which had developed in Germany to initiate a revival, and assist in creating an Italian Romanesque style. In the thirteenth century, again, Gothic art, with its centre in the Ile de France, gave new life to painting and sculpture in Tuscany and North Italy, extending its influence down the Rhône valley, along the Ligurian coast, and over the western passes of the Alps. The establishment of the Popes at Avignon helped to turn the tide the other way; and along the channel so established Sienese influence was able to travel northward to Paris, and to play a decisive part in shaping the last phase of Gothic painting, the so-called International Gothic style. From Paris and north-east France as centre, the influence of this radiated to England, the Rhine valley, Austria, Bohemia, and North Italy, where again it played a part in shaping style.

Meanwhile, however, indigenous forces were working themselves out in Italy. Pietro Cavallini at Rome modelled his types and his treatment of form on Roman sculpture; and the work of his school at Assisi spread his influence widely. Niccolà Pisano may have brought from the South memories

of Hellenistic work; and the Pisan school of sculpture helped to teach the painters of Tuscany. Influences such as these combined with the native genius of Giotto to produce an art in which construction of design in three dimensions, sculpturesque treatment of form, and power of dramatic expression mark it as basically different from Gothic. It is often said that the Franciscan movement was an important factor in this development. So far as it helped to create a market for a more realistic and dramatic art, this is true. But it is doubtful whether the ideas inspiring Giotto and his followers derive from Franciscan teaching. More probably they were part of a wider movement in thought of which the ideas of St Francis were a parallel expression. Another factor which favoured the rise of Giotto and his school was that architecture in Italy, despite Gothic influence, continued to leave ample wall space for the painter; and that painted glass was no serious competitor with his work. As a result, the painter in Italy was better able than the painter in the North to develop his own style without reference to the other arts.

For a period, painting in Italy oscillated between the ideals of Giotto and of northern Gothic; and that oscillation provides an interesting example of the influence of patronage on style. In North Italy, the courts of the despots somewhat resembled those of the feudal lords of northern Europe; and there Gothic ideals found a congenial home. In Tuscany,

especially in Florence, political and economic power was held more or less alternately by a despot supported by the working classes and the small bourgeoisie and an oligarchy drawn from the great bourgeois families. According to which was in the ascendant, so was the Gothic or Giottesque outlook on painting in favour.

By the early fifteenth century humanist ideas were in the ascendant in Florence, and painting became mainly humanist in character, influencing by its example painting elsewhere in North and Central Italy. Inspired by a conception of man as the central and dominant figure of the Universe; and by a new sense of interest in every aspect of man's environment, this humanist art had as a central aim the creation of an impression of reality. For this, expression of the third dimension was essential, also the establishment of unity of place, of time, and of action; and to the search for these qualities was harnessed the study of perspective, of anatomy, and of light and shade. Full achievement was attained in the early sixteenth century; and to this several factors contributed. Conditions of patronage made it possible. Most patrons of art in Italy were deeply imbued with humanist ideas; and their frequent interventions concerning subject and its treatment were more in the nature of informed co-operation than restrictive dictation. The correspondence of artists of the period yields many plaintive cries for payment; but rarely a complaint

of lack of sympathy and encouragement. It is possible even that sympathetic direction of the artist increased his creative power by relieving him of uncertainty and responsibility.

In his relation to the other arts the painter was fortunate. Both architect and sculptor helped him to attain his ends: the one, by assisting him in the mastery of perspective; the other, by strengthening his grasp of form. Scientific research played its part in the same way. The study of anatomy contributed to the painter's ability to express movement; solid and plane geometry lay at the root of the construction of his designs.*

The influence of classical art is more difficult to assess. Despite the limited number of examples available for study, classical sculpture occasionally provided motives for a painting; and in the sixteenth century, the Venus Pudica and other statues inspired designs which have been repeated with variations until today. But such evidence as there is, suggests that classic art chiefly exercised influence through the theories which it inspired. These theories, of which Renaissance Italy from the time of Alberti onwards was a mighty breeding-ground, at first developed independently of practice and had little influence upon it. Later, however, they combined with surviving examples of classic

* Comparable is the use made of scientific theories regarding light by certain Impressionists, and in particular by Seurat.

art to form a guide to taste and a touchstone of merit; and the outlook and methods of the Mannerist painters of the sixteenth century, and of the Eclectics, were largely the outcome of putting the practice of painting to the test of theory. With the growth of academies in the late sixteenth and early seventeenth centuries, theory reinforced its hold upon practice. The empirical methods of the old *bottega*, as expounded, for example, in the *Trattato della Pittura* of Cennino Cennini, standardised technique rather than its application. But in the academies, drawing, design, distribution of light and shade, facial expression, costume, all tended to become a matter of rules; and teaching so given was crystallised in the manuals of instruction which became common in the seventeenth and eighteenth centuries. The methods of Poussin were largely based upon his theories, and correspondence can be traced between variations in his style, and changes in his theories; while comparison of the work of a long succession of painters in eighteenth-century England and France with the precepts of the manuals, well illustrates how theory can, on occasion, control style.

Other influences however, more potent than theory, were shaping post-Renaissance painting, and leading to the emergence of the Baroque, and its more flippant and graceful descendant, the Rococo. The main breach here with the style of the High Renaissance is in design. The High

Renaissance sought for unity: but it was a unity which accepted the individuality and separate existence of each part of a work of art, and which was itself complete and self-sufficient. In Baroque painting, unity is still the aim; but the identity of the component parts of a picture is submerged by larger rhythms, which carry any movement within the picture outside its frame, and make it part of a larger, indeterminate whole.

The cause of such a development lies, like the development from Gothic to Renaissance painting, in a change of attitude towards the Universe. Whether the Catholic Revival inspired such a change, or was merely a symptom of a wider movement, is in question; but it certainly represented a movement away from humanism, which in art replaced poise and self-sufficiency by a reaching out towards contact with the unknown.

But such a change of attitude does not account for the particular form taken by Baroque painting, with its combination of sweeping, disruptive design and extravagant realism. The explanation must be sought in certain characteristics of High Renaissance painting, which bore within them the seeds of the Baroque. At the highest point of its achievement, High Renaissance art carried within itself the causes of its own dissolution. In the search for unity within the picture, the handling of light and shade became increasingly important. With the establishment of consistent lighting and the im-

plication of a source of light outside the picture, the self-contained quality of the work disappeared; while the temptation increased to use light and shade, rather than position in space, as the means of binding the constituent forms of the work together. So it is that Correggio is a herald of the Baroque. Again, High Renaissance ideals necessarily limited the use of too-violent action, as destructive of unity: but the possibility of exploiting movement in the human body as an aid to three-dimensional design was too strong for most painters; and made Michelangelo father of the extravagant and exaggerated gestures which mark much Baroque painting. Thirdly, though the High Renaissance painter was not interested in the accumulation of realistic detail, in certain parts of his works, such as types and facial expression, he pushed realism to an extreme point in the sense of conforming to conventions that were accepted as appropriate. It was but a short step from this to try to find, as did Caravaggio, types and expressions appropriate to the subject in the painter's daily surroundings.

How far these developments were helped by external influences it is difficult to say. Certainly they received a warm welcome from the Church, and especially from the Jesuits; and so patronage again helped to make a style movement powerful. The possibility of incitement from the Far East also must not be ignored. As the result of the extension of trade routes, Chinese art was beginning to come

into Europe; and that art was Chinese Baroque. Whether at this period it exercised appreciable influence is difficult to say; but if so, the importance of geography in relation to style is confirmed.

The Baroque style spread throughout Europe; and with its spreading, the artistic centre of gravity moved from Italy to the North. The combination of sweeping rhythmic design and realistic detail is closely akin to the ideals of the late Gothic painters and found a ready welcome among their descendants. In Flanders and France, the Baroque style was mainly developed on its decorative side; in Holland, in hands such as those of Jan Steen, it was the realistic element that received emphasis.

Following the Baroque, comes its transmutation into the Rococo, the rise of the Neo-classic movement, the Romantic revival, the growth of Realism and the development of Impressionism. These however bring to light no influences bearing on style hitherto unconsidered. But they reinforce the suggestion put forward that each style carries within it elements from which the succeeding style is born, the resultant growth being shaped by external conditions. Neo-classic propensities were visible in Rococo painting long before David rose to fame; Neo-classicism had its Romantic side, in the early work of Ingres and of the Nazareni; Courbet and the Realists nourished themselves on the works of Delacroix the Romantic; and in Dela-

croix and Realism, the ideas and methods which inspired the Impressionists are present.

Closely connected with this tentative conclusion is another: that the activity of man as an artist is definitely and at times closely linked with his other activities; and is part of a general movement of the human spirit, and not an isolated phenomenon. If this be the case, the study of art history, or indeed the study of a single work of art, cannot be carried on *in vacuo*, but must treat art as one element in a complex mass of activities, which may influence it or in turn be influenced by it, and in terms of which it can alone be fully understood. But such a view equally implies abandonment of the idea that art only takes on life and meaning by virtue of other activities; and carries with it acceptance of the view that art has a vitality of its own, which makes its own contribution to the pattern of men's thoughts and actions.

§ vii

FTER consideration of how and why a work
of art has received its distinctive form, the
question of its significance or importance
arises. In this connection, the term 'importance'
may have either of two meanings. It may imply
that a work is historically important, in that it
throws light on the development of a particular
master, helps to explain the formation of a certain
style characteristic, illustrates the operation of some
formative influence on style, and so on; but at the
same time implies nothing as to the work's artistic
merits. Such estimates of importance, the art
historian is constantly called upon to make. Fortu-
nately for him, the tests to be applied are largely
objective. It is mainly a question of demonstrable
fact, based upon analysis of a work of art and the
conditions surrounding its production, as to whether,
for example, such-and-such a characteristic in a
work is due to the influence of another artist, to
the influence of a patron, or to the circumstances of
the artist's life, etc.

But another type of importance, aesthetic im-
portance, is a different matter. When this has to be
judged, the art historian enters the realm of the art

critic, sharing with him the fundamental weakness of lacking any standards of judgment except his own findings as to what is good and bad. Innumerable manuals have been written, and innumerable lectures delivered, concerning tests of the good or bad in art. But ultimately, as a distinguished critic has remarked, these all boil down to a feeling in the midriff: in other words, such tests are merely the elaboration and ratiocination of the spectator's own metaphysic as to goodness or badness. Mercifully for him, the art historian, unlike the art critic, has not, as a necessary and indispensable part of his work, always to decide as to merit. But on occasion he must do so; otherwise, the use of such terms, for example, as 'decadence' or 'progress' are in his work quite meaningless. It is arguable whether any historian should make judgments at all; but experience shows that, in fact, estimates of work are unavoidable, if history is to be living. But when the art historian has to judge, he can at least comfort himself with the thought that he approaches the task more fully informed, and more disciplined, than most of his fellow-men; that when he judges, he realises his difficulties and responsibilities; and if his contemporaries or posterity hold him to be wrong, that other aspects of his work at least may justify his existence and his labours.